Georgia O'Keeffe Museum

HIGHLIGHTS FROM THE COLLECTION

EDITED BY

BARBARA BUHLER LYNES

HARRY N. ABRAMS, INC., PUBLISHERS, IN ASSOCIATION WITH THE GEORGIA O'KEEFFE MUSEUM

FOREWORD

THE GEORGIA O'KEEFFE MUSEUM, in Santa Fe, New Mexico, opened to the public in July 1997, eleven years after the death of the artist from whom it takes its name. Since then, the Museum has welcomed more than 1,000,000 visitors from all over the world—visitors who have experienced the Museum's success in meeting its goals of honoring and perpetuating O'Keeffe's artistic legacy and defining her significant role in the development of American Modernism. It is rare for any artist to have an institution created primarily to exhibit his or her work, but philanthropists Anne and John Marion recognized the breadth of O'Keeffe's art, its appeal to a wide variety of audiences, and its increasing international importance. They became committed to honoring the artist's achievement in a major way.

Over the course of her career, O'Keeffe worked in several parts of the country—significantly in New York, where her career began in 1916, when she was twenty-nine. The Marions, however, decided to establish the Museum in Northern New Mexico, the area with which the artist is most often associated. Northern New Mexico was O'Keeffe's spir-

itual home from 1929, when she began spending summers there, and was her permanent home from 1949 until her death.

The Marions began amassing the core of what would become the world's largest collection of O'Keeffe's work, and they wished to house it in a way that would be sympathetic to its character. For this, they engaged the well-known New York architectural firm of Gluckman Mayner, which set about transforming and expanding one of Santa Fe's older buildings into an elegant and gracious exhibition space.

Since its opening, the Museum has developed a series of distinguished exhibition and educational programs. These acquaint visitors with the diversity of O'Keeffe's accomplishments and, more broadly, the modernist era in which she worked and which she helped define.

The Museum organizes exhibitions of O'Keeffe's work from its own collection and hosts O'Keeffe exhibitions organized by other institutions to provide visitors with new perspectives on the significance of the artist's work. To illuminate O'Keeffe's importance within the history of American art, the Museum also organizes and hosts exhibitions that

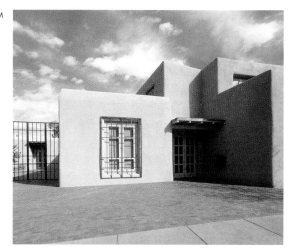

combine O'Keeffe's work with that of her contemporaries. In addition, it sponsors an exhibition series devoted to living artists of distinction—especially those whose works share a similar artistic legacy with O'Keeffe's.

The Museum's educational and outreach programs complement the Museum's exhibition programs. Through approaches ranging from lecture series to hands-on creative experiences, the programs offer persons of all age groups a variety of opportunities to enrich their understanding both of O'Keeffe and other American artists, specifically emphasizing the milieu in which they worked. Of particular note in this Museum endeavor is the innovative Art and Leadership Program for Girls, which has received national acclaim.

In July 2001, the Museum opened the Georgia O'Keeffe Museum Research Center, the only museum-related facility dedicated to the study of American Modernism (1890 to the present). The Center is located two blocks from the Museum in a historic building that was also renovated and expanded by Gluckman Mayner Architects.

Through its annual, competitive scholarship program, the Research Center sponsors research by historians in the fields of art history, architectural history and design, literature, music, and photography. Six scholarships, ranging from three to twelve months' duration, are available to applicants at the pre- and post-doctoral levels, and one scholarship is available to a museum professional or otherwise qualified individual interested in organizing an exhibition pertaining to American Modernism for the Georgia O'Keeffe Museum. In addition, the Research Center's programs of lectures, publications, and symposia (on-site and virtual) complement the Museum's objectives, its exhibitions, and its educational programs.

For its scholars, the Research Center provides office space as well as access to its various collections and facilities. These collections are also available by appointment to other qualified scholars and include archival materials related to O'Keeffe and her contemporaries, a research library that includes the books Georgia O'Keeffe kept at her Ghost Ranch house, and the extensive collection of works by O'Keeffe and others in the Museum collection.

Another component of the Research Center is the house and studio at Ghost Ranch, about sixty miles northwest of Santa Fe, where O'Keeffe lived and worked part of each year

3

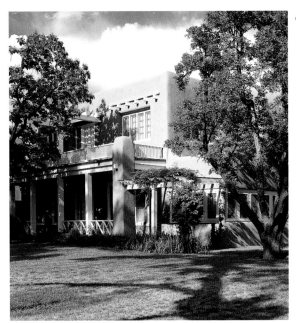

4

from the mid-1930s through the mid-1970s. The house, which is owned by the Museum, is set within the stunning landscape configurations that provided much of the subject matter seen in O'Keeffe's art for more than forty years.

Over the course of a sixty-year career, O'Keeffe created more than 2,000 drawings, paintings, and sculptures. Aside from those that are privately owned, many of her works are in eminent museum collections in the United States and abroad. But it is only at the Georgia O'Keeffe Museum that the visitor can experience the largest single grouping of her art, including examples of her work from each of the six decades in which she was active professionally. The Museum is fortunate to own a full range of O'Keeffe's works, including a number of her most significant and iconic images, from her daring and innovative abstractions of the 1910s and 1920s, to her elegant and often provocative investigations into

subject matter that included architecture, still lifes, landscapes, flowers, and bones. All demonstrate her consummate skill and convey her unique and compelling vision.

We hope that this foreword will give the reader a sense of the Georgia O'Keeffe Museum and its exciting programs. And we hope that the compilation of the sixty-three wonderful images that follows will provide the reader with a sense of the Museum's extensive collection of more than 130 works by the artist and an insight into her singular approach to distilling her vision of the world through her art.

To understand O'Keeffe's intention fully, one must experience her work first hand. We therefore hope that this publication will encourage readers to join us in our celebration of one of America's most important artists by visiting the Georgia O'Keeffe Museum.

GEORGE G. KING, DIRECTOR
Georgia O'Keeffe Museum

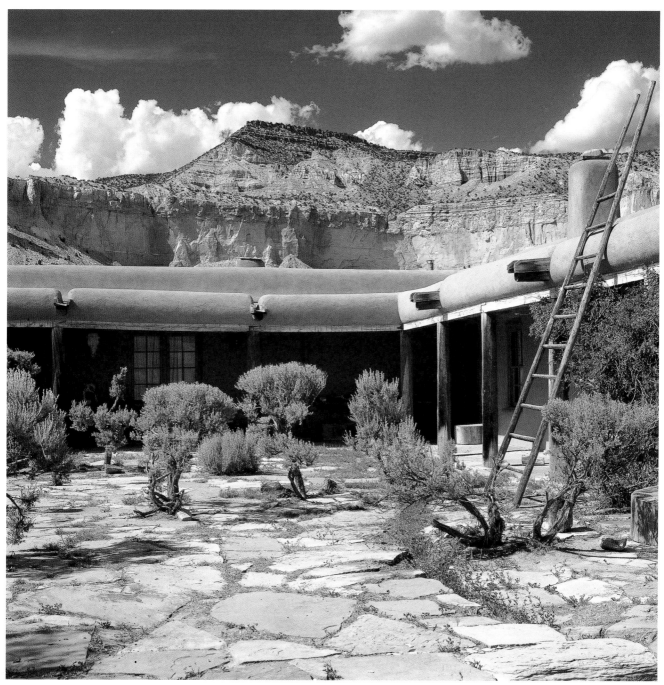

GHOST RANCH

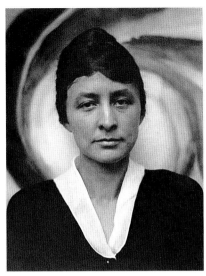

BIOGRAPHY

GEORGIA O'KEEFFE was born on November 15, 1887, the second of seven children, and grew up on a farm in Sun Prairie, Wisconsin. As a child she received art lessons at home, and her abilities were quickly recognized and encouraged by teachers throughout her school years. By the time she graduated from high school in 1905, O'Keeffe had determined to make her way as an artist. She pursued studies at The Art Institute of Chicago (1905–6) and at The Art Students League, New York (1907–8), where she was quick to master the principles of imitative realism—the approach to art-making that then formed the basis of the curriculum. In 1908, she won the League's William Merritt Chase still-life prize for her oil painting *Untitled (Dead Rabbit with Copper Pot)*. Shortly thereafter, however, O'Keeffe quit making art, saying later that she had realized she could never achieve distinction working within this tradition.

Her interest in art was rekindled four years later, when she took a summer course for art teachers at the University of Virginia, Charlottesville, taught by Alon Bement of Teachers College, Columbia University. Bement introduced O'Keeffe to the then-revolutionary ideas of his colleague at Teachers College, artist and art educator Arthur Wesley Dow. Dow believed that the goal of art was the expression of the artist's personal ideas and feelings, and that such subject matter was best realized through harmonious arrangements of line, color, and *notan* (the Japanese system of lights and darks). Dow's ideas offered O'Keeffe an alternative to imitative realism, and she experimented with them for two years, while she was either teaching art in the Amarillo, Texas, public schools or working summers in Virginia as Bement's assistant. O'Keeffe was in New York again from fall 1914 to June 1915, taking courses at Teachers College. By the fall of 1915, when she was teaching art at Columbia College, Columbia, South Carolina, she decided to put Dow's theories to the test. In an attempt to discover a personal language through which she could express her own feelings and ideas, she began a series of abstract charcoal drawings that are now recognized as being among the most innovative in all of American art of the period. She mailed

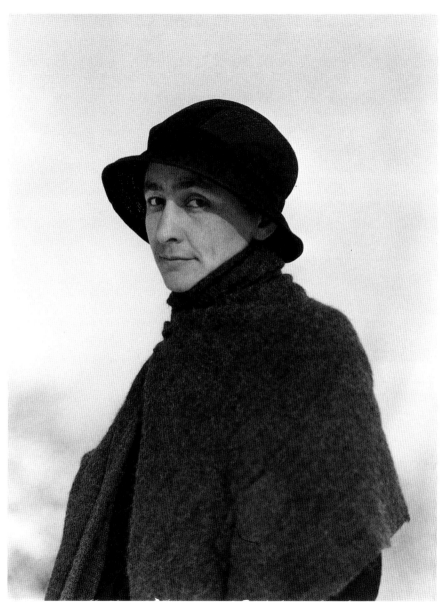

ALFRED STIEGLITZ
GEORGIA O'KEEFFE
1924
Gelatin silver print
4⅞ x 3⅞ inches
Gift of The Georgia O'Keeffe Foundation

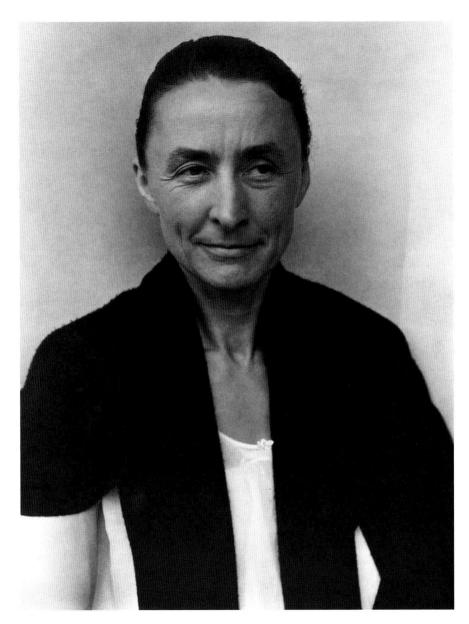

ALFRED STIEGLITZ
GEORGIA O'KEEFFE
1932
Gelatin silver print
9⅛ x 7¼ inches
Gift of The Georgia O'Keeffe Foundation

some of these drawings to a former Columbia classmate, who showed them to the internationally known photographer and art impresario, Alfred Stieglitz, on January 1, 1916.

Stieglitz began corresponding with O'Keeffe, who returned to New York that spring to attend classes at Teachers College, and he exhibited ten of her charcoal abstractions in May at his famous avant-garde gallery, 291. A year later, he closed the doors of this important exhibition space with a one-person exhibition of O'Keeffe's work. In the spring of 1918, Stieglitz offered her financial support to paint for a year in New York. O'Keeffe, who had been affiliated with the West Texas State Normal College, Canyon, since the fall of 1916, arrived in New York in June. She and Stieglitz fell in love, were married in 1924, and subsequently lived and worked together in New York City (winter and spring) and at the Stieglitz family estate at Lake George, New York (summer and fall), until 1929, when O'Keeffe spent the first of many summers painting in New Mexico.

From 1923 until his death in 1946, Stieglitz worked assiduously and effectively to promote O'Keeffe and her work, organizing annual exhibitions of her art at The Anderson Galleries (1923–25), The Intimate Gallery (1925–29), and An American Place (1929–46). As early as the mid-1920s, when O'Keeffe first began painting large-scale depictions of flowers seen as if close up, which are among her best-known works, she had become recognized as one of America's most important and successful artists.

Three years after Stieglitz's death, O'Keeffe moved from New York to her beloved New Mexico, whose stunning vistas and stark landscape configurations had inspired her work since 1929. She divided the year between her Ghost Ranch house, which she purchased in 1940, and the house she purchased in Abiquiu in 1945.

O'Keeffe continued to work in oil until the mid-1970s, when failing eyesight forced her to abandon painting. She continued working in pencil and watercolor and also produced objects in clay from 1973 until her health failed in 1984. She died two years later, at the age of 98.

BARBARA BUHLER LYNES

PLATES

ABSTRACTIONS

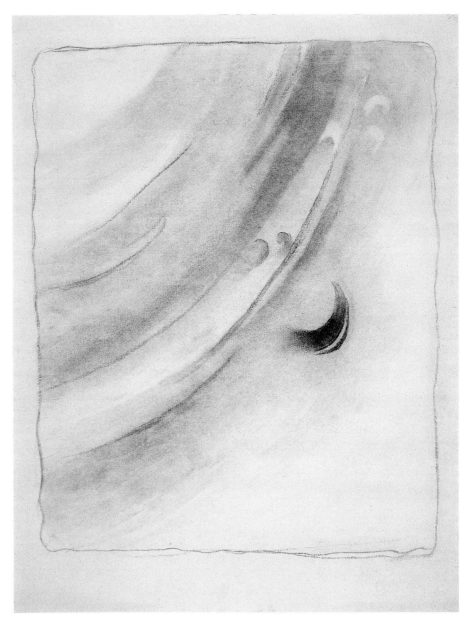

ABSTRACTION
WITH CURVE AND CIRCLE
c. 1915/16
Charcoal on paper
23¾ x 18⅜ inches
Gift of The Burnett Foundation
and The Georgia O'Keeffe Foundation

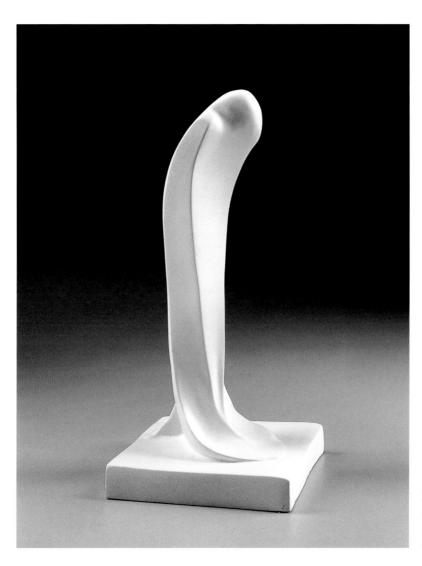

ABSTRACTION
1916 (cast 1979/1980)
White lacquered bronze
10 x 10 x 1½ inches
Gift of The Burnett Foundation

14

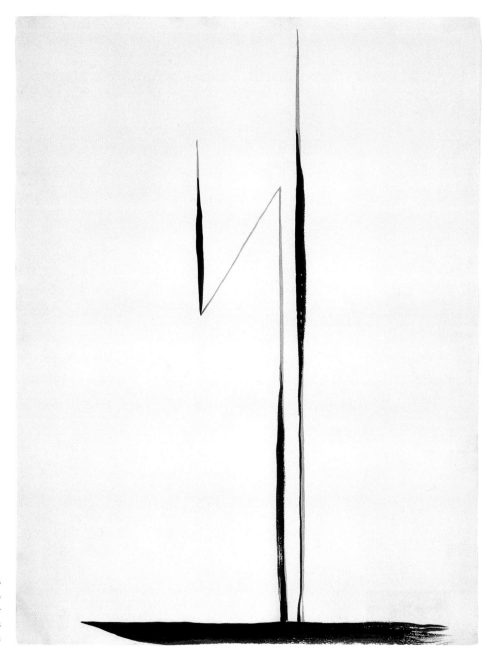

BLACK LINES
1916
Watercolor on paper
24½ x 18½ inches
Promised gift, The Burnett Foundation

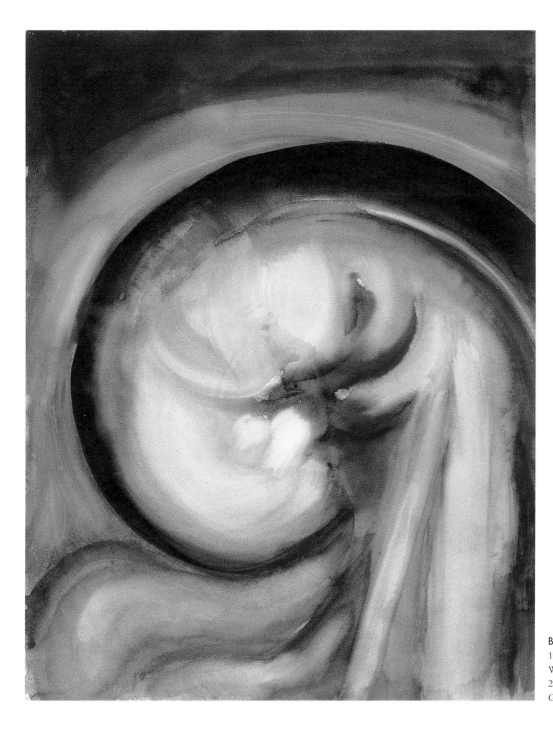

BLUE II
1916
Watercolor on paper
27⅞ x 22¼ inches
Gift of The Burnett Foundation

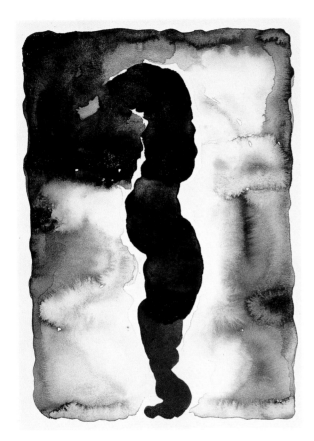

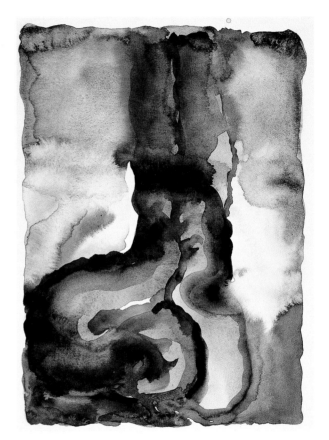

1 UNTITLED
(ABSTRACTION/PORTRAIT OF PAUL STRAND)
1917
Watercolor on paper
12 x 8⅞ inches
Promised gift, The Burnett Foundation

2 PORTRAIT—W—NO. III
1917
Watercolor on paper
12 x 8⅞ inches
Gift of The Burnett Foundation
and The Georgia O'Keeffe Foundation

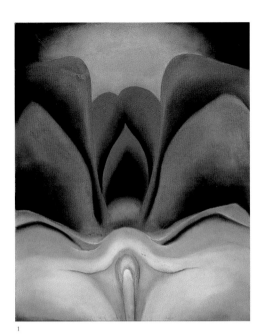

1

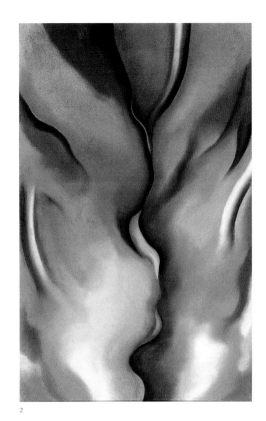

2

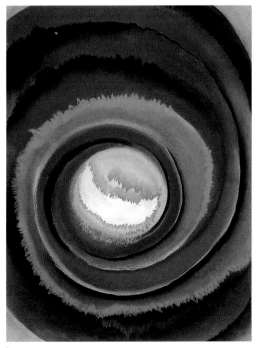

3

1 BLUE FLOWER
 1918
 Pastel on paper mounted to cardboard
 20 x 16 inches
 Promised gift, The Burnett Foundation

2 ABSTRACTION OF STREAM
 1921
 Pastel on paper
 27¾ x 17½ inches
 Promised gift, The Burnett Foundation

3 POND IN THE WOODS
 1922
 Pastel on paper
 24 x 18 inches
 Promised gift, The Burnett Foundation

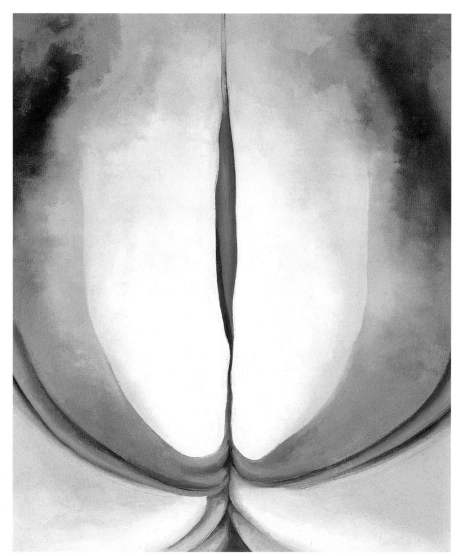

BLUE LINE
1919
Oil on canvas
20⅛ x 17⅛ inches
Gift of The Burnett Foundation
and The Georgia O'Keeffe Foundation

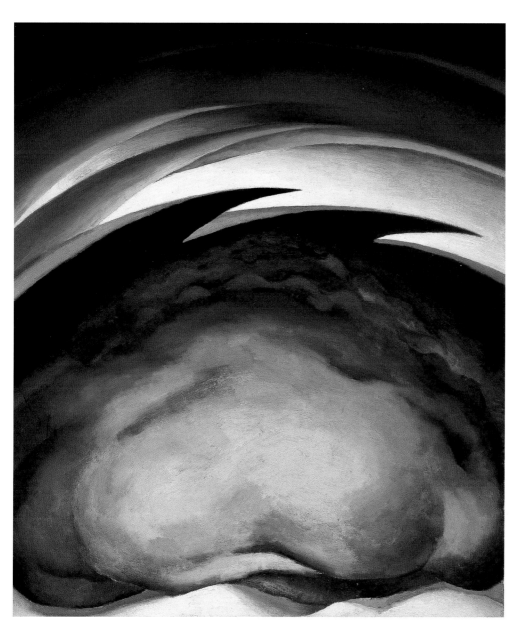

SERIES I—
FROM THE PLAINS
1919
Oil on canvas
27 x 23 inches
Promised gift, The Burnett Foundation

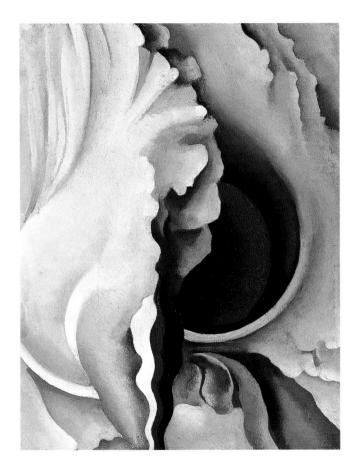

THE BLACK IRIS
1926
Oil on canvas
9 x 7 inches
Promised gift, The Burnett Foundation

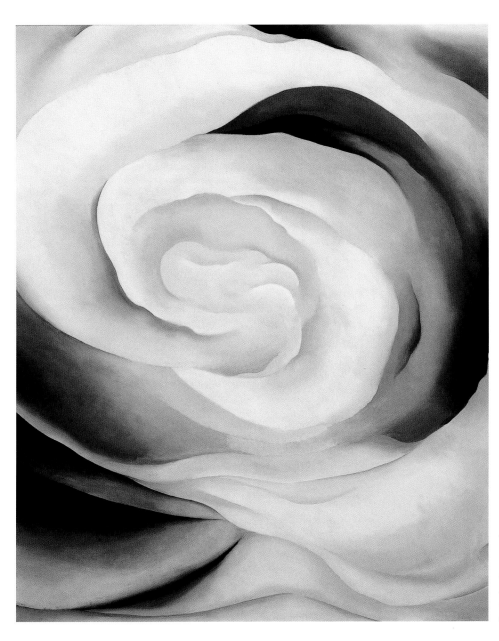

ABSTRACTION WHITE
ROSE
1927
Oil on canvas
36 x 30 inches
Gift of The Burnett Foundation
and The Georgia O'Keeffe Foundation

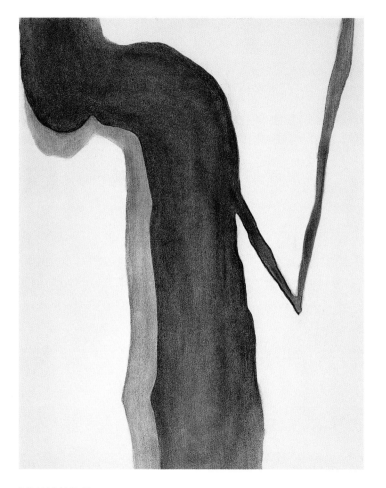

DRAWING V
1959
Charcoal on paper
24½ x 18¾ inches
Gift of The Burnett Foundation
and The Georgia O'Keeffe Foundation

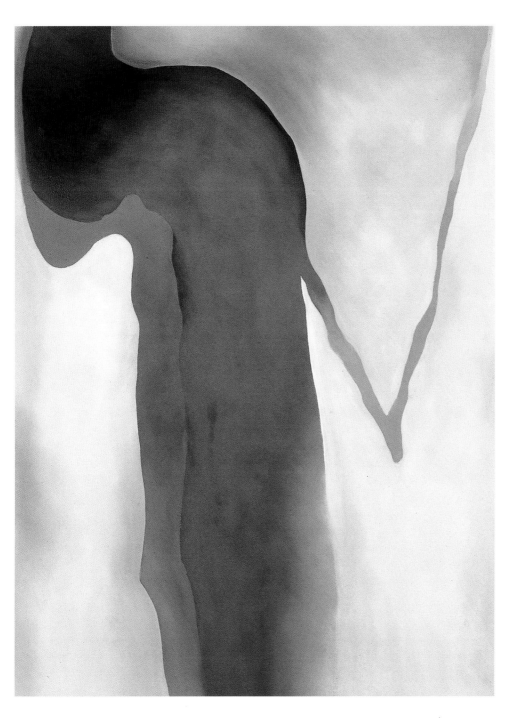

BLUE BLACK AND GREY
1960
Oil on canvas
40 x 30 inches
Promised gift, The Burnett Foundation

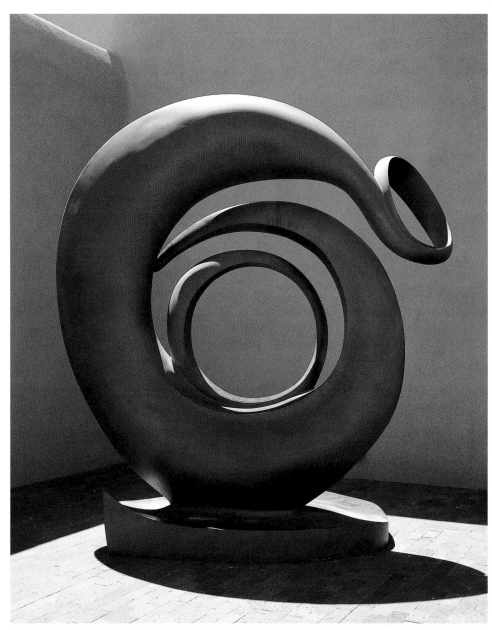

24

ABSTRACTION
1946 (cast 1979/1980)
Cast aluminum
118 x 118 x 57¾ inches
Gift of The Burnett Foundation
and The Georgia O'Keeffe Foundation

ARCHITECTURAL FORMS

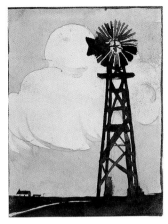

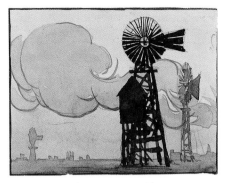

1 UNTITLED (WINDMILL)
1916
Watercolor and graphite on paper
4¾ x 3⅜ inches
Promised gift, The Burnett Foundation

2 UNTITLED (WINDMILLS)
1916
Watercolor and graphite on paper
3⅜ x 4¾ inches
Promised gift, The Burnett Foundation

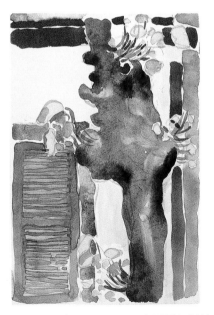

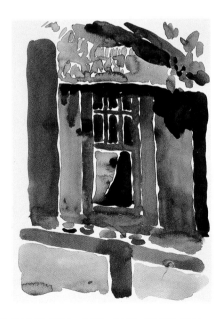

3 UNTITLED (TREE WITH GREEN SHADE)
1918
Watercolor and graphite on paper
8⅞ x 6 inches
Promised gift, The Burnett Foundation

4 WINDOW—RED AND BLUE SILL
1918
Watercolor on paper
12 x 9 inches
Gift of The Burnett Foundation

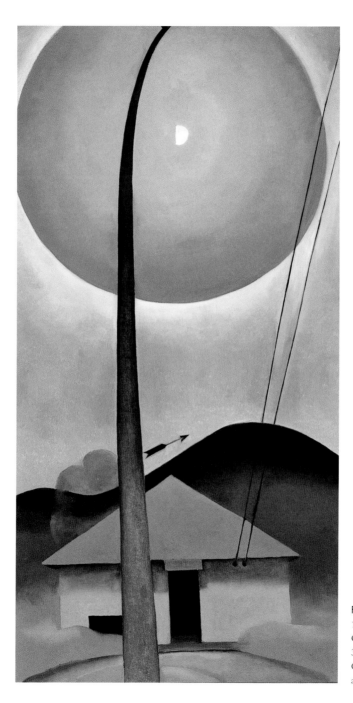

FLAGPOLE
1925
Oil on canvas
35 x 18¼ inches
Gift of The Burnett Foundation
and an anonymous donor

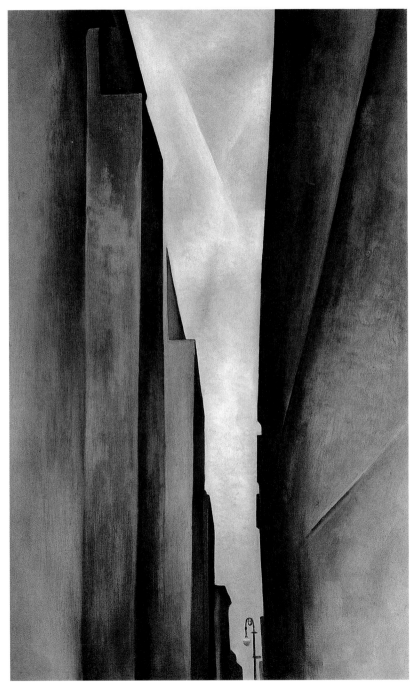

A STREET
1926
Oil on canvas
48⅛ x 29⅞ inches
Gift of The Burnett Foundation

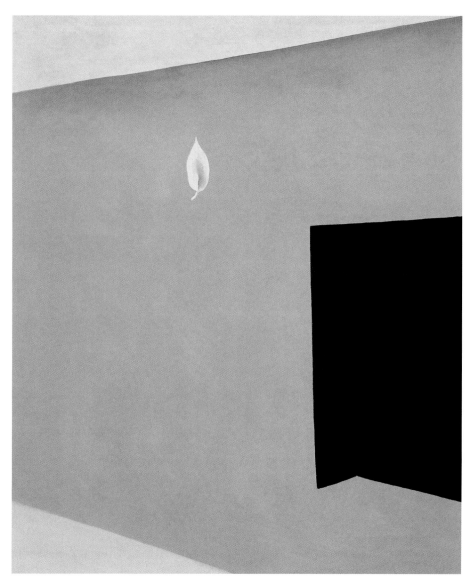

PATIO DOOR
WITH GREEN LEAF

1956

Oil on canvas

36 x 30 inches

Gift of The Burnett Foundation

and The Georgia O'Keeffe Foundation

MY LAST DOOR
1952/54
Oil on canvas
48 x 84 inches
Gift of The Burnett Foundation

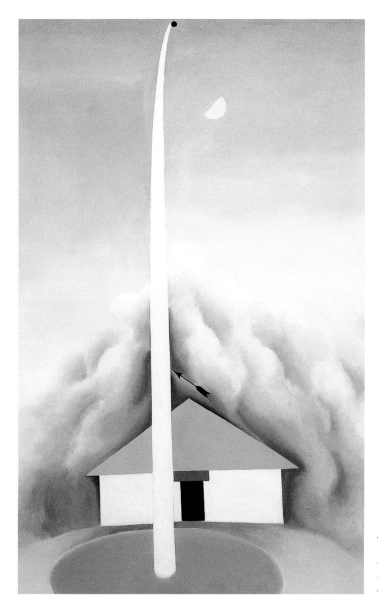

FLAG POLE
AND WHITE HOUSE
1959
Oil on canvas
48 x 30 inches
Gift of Emily Fisher Landau

HUMAN FIGURES

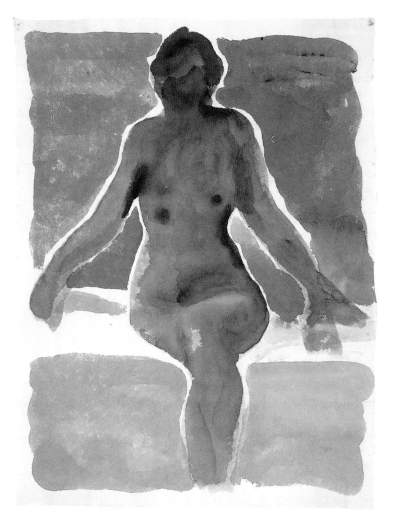

NUDE SERIES VII
1917
Watercolor on paper
17¾ x 13½ inches
Gift of The Burnett Foundation
and The Georgia O'Keeffe Foundation

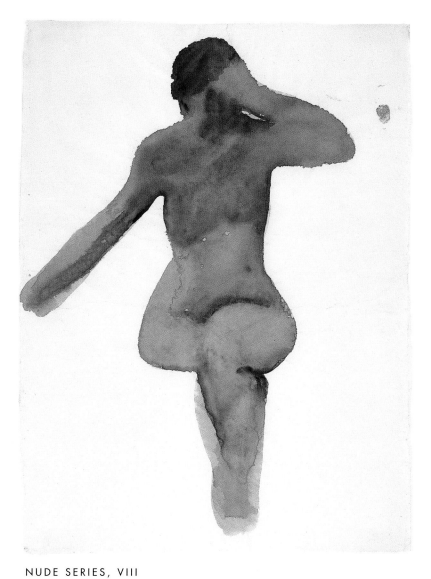

NUDE SERIES, VIII
1917
Watercolor on paper
18 x 13½ inches
Gift of The Burnett Foundation
and The Georgia O'Keeffe Foundation

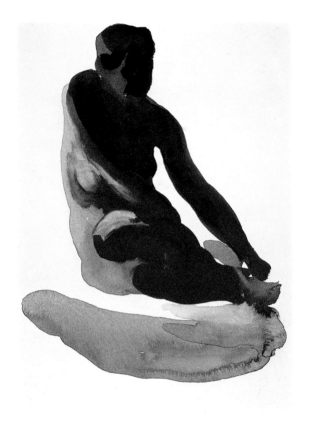

NUDE SERIES
1917
Watercolor on paper
12 x 8⅞ inches
Gift of The Burnett Foundation
and The Georgia O'Keeffe Foundation

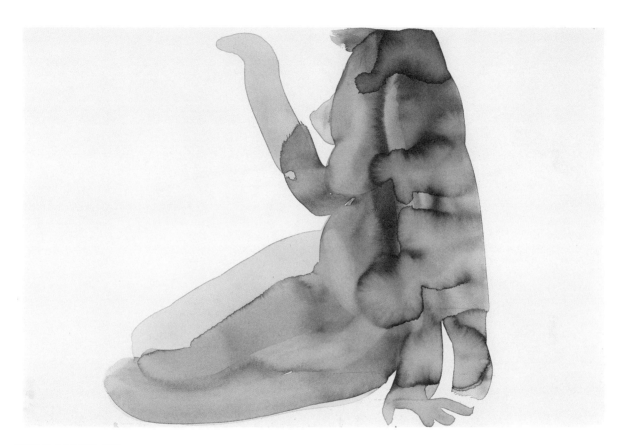

NUDE SERIES XII
1917
Watercolor on paper
12 x 17⅞ inches
Gift of The Burnett Foundation
and The Georgia O'Keeffe Foundation

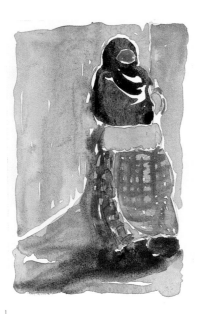

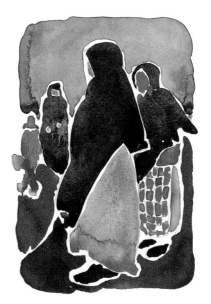

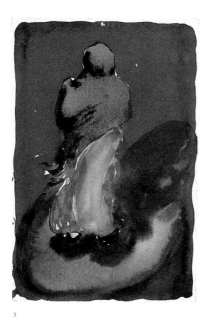

1 **WOMAN WITH APRON**
1918
Watercolor and graphite on paper
8¾ x 6 inches
Gift of The Burnett Foundation

2 **THREE WOMEN**
1918
Watercolor and graphite on paper
8⅞ x 6 inches
Gift of Gerald and Kathleen Peters

3 **WOMAN WITH BLUE SHAWL**
1918
Watercolor, graphite, and charcoal on paper
8⅞ x 6 inches
Promised gift, The Burnett Foundation

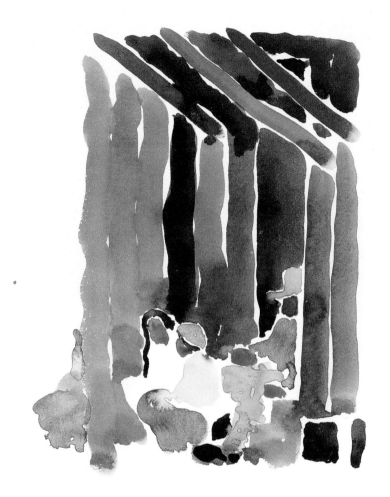

FIGURES UNDER ROOFTOP
1918
Watercolor on paper
12 x 9 inches
Gift of Gerald and Kathleen Peters

FOUND OBJECTS

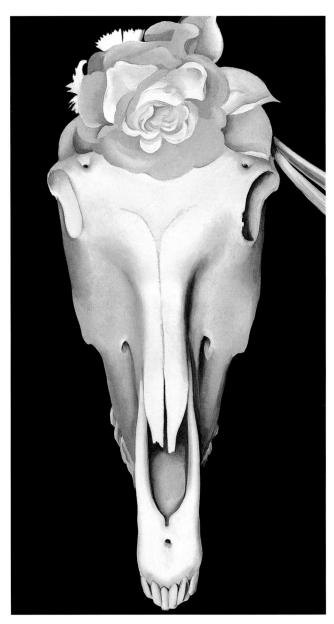

HORSE'S SKULL WITH
WHITE ROSE
1931
Oil on canvas
30 x 16⅛ inches
Extended loan, private collection

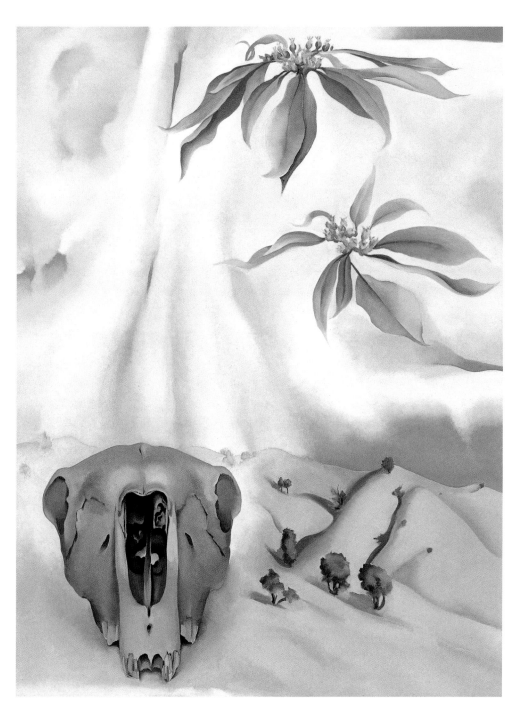

MULE'S SKULL
WITH PINK POINSETTIA
1936
Oil on canvas
40⅛ x 30 inches
Gift of The Burnett Foundation

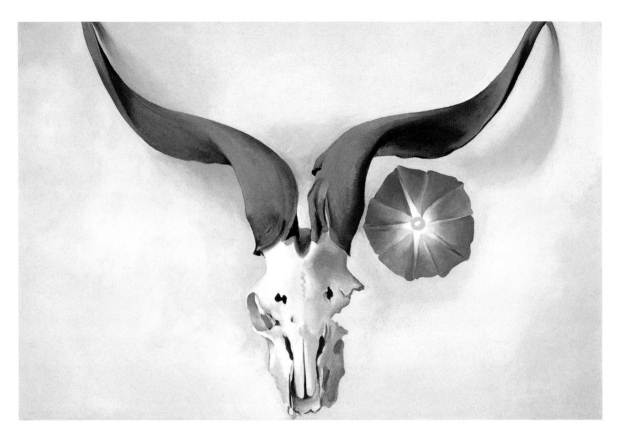

RAM'S HEAD, BLUE MORNING GLORY
1938
Oil on canvas
20 x 30 inches
Promised gift, The Burnett Foundation

PELVIS SERIES, RED WITH YELLOW
1945
Oil on canvas
36⅛ x 48⅛ inches
Extended loan, private collection

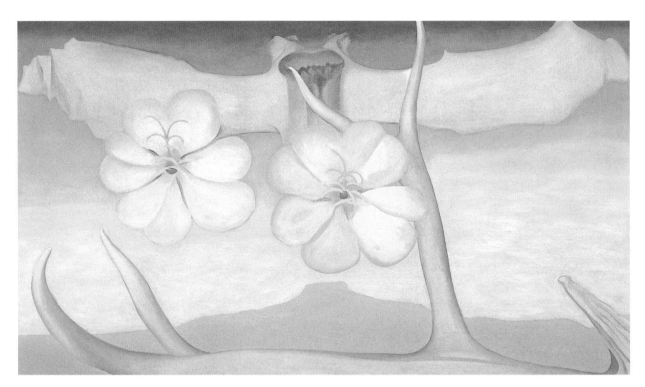

SPRING
1948
Oil on canvas
48¼ x 84¼ inches
Gift of The Burnett Foundation

FRUITS, PLANTS, AND FLOWERS

(ORGANIC FORMS ISOLATED FROM THEIR ENVIRONMENTAL CONTEXT)

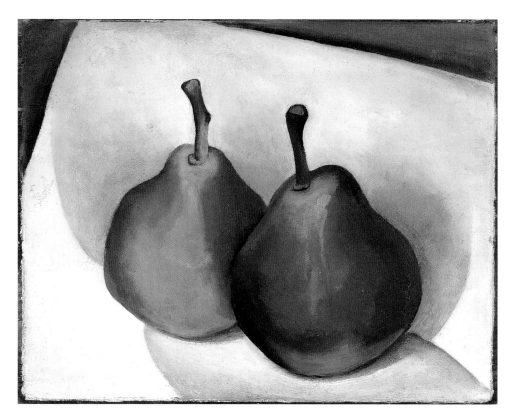

UNITLED (TWO PEARS)
1921
Oil on board
8⅞ x 10 inches
Promised gift, The Burnett Foundation

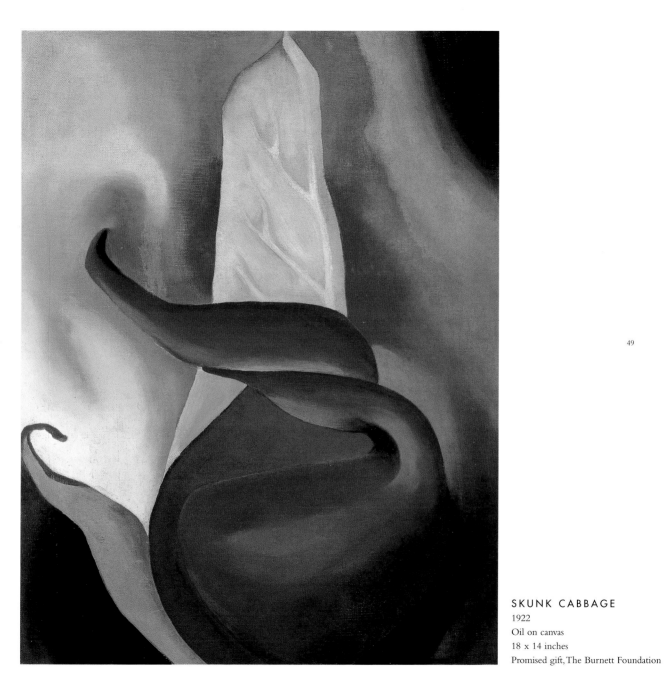

SKUNK CABBAGE
1922
Oil on canvas
18 x 14 inches
Promised gift, The Burnett Foundation

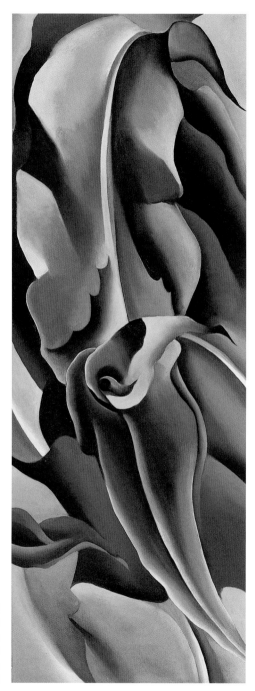

CORN, NO. 2
1924
Oil on canvas
27¼ x 10 inches
Gift of The Burnett Foundation
and The Georgia O'Keeffe Foundation

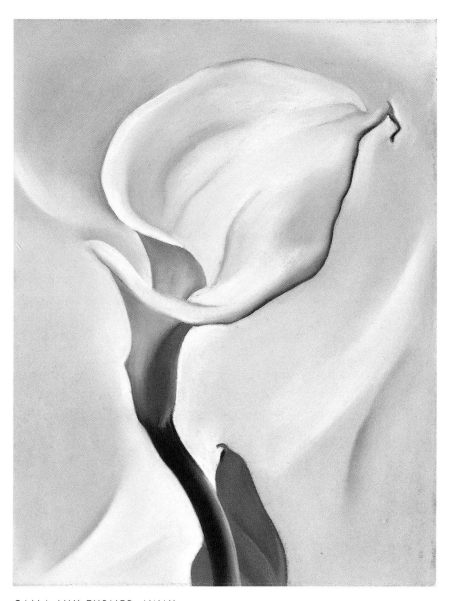

CALLA LILY TURNED AWAY
1923
Pastel on paper-faced cardboard
14 x 10⅞ inches
Gift of The Burnett Foundation

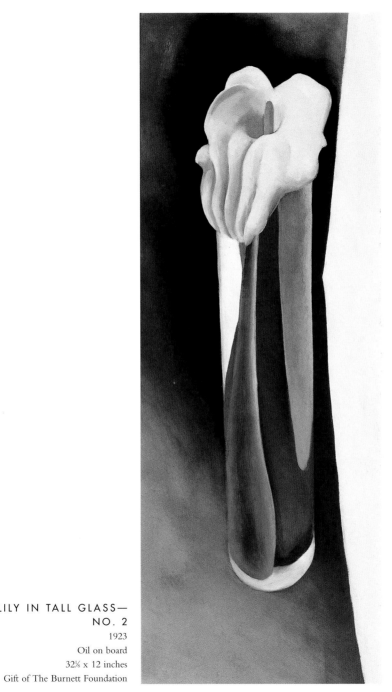

52

CALLA LILY IN TALL GLASS—
NO. 2
1923
Oil on board
32⅛ x 12 inches
Gift of The Burnett Foundation

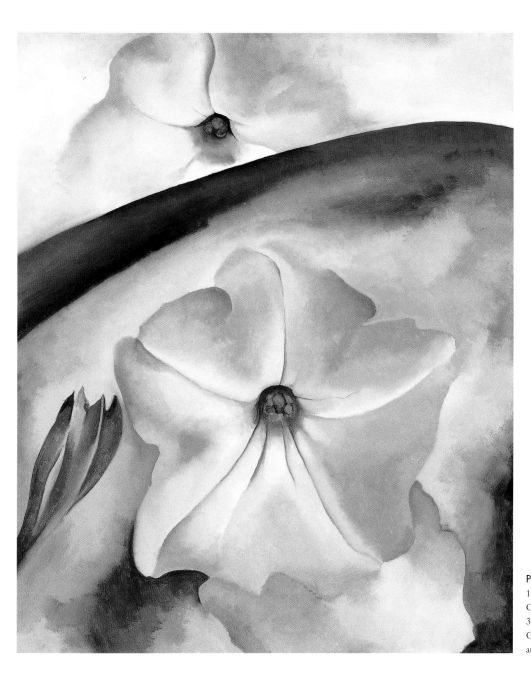

PETUNIA NO. 2
1924
Oil on canvas
36 x 30 inches
Gift of The Burnett Foundation
and The Georgia O'Keeffe Foundation

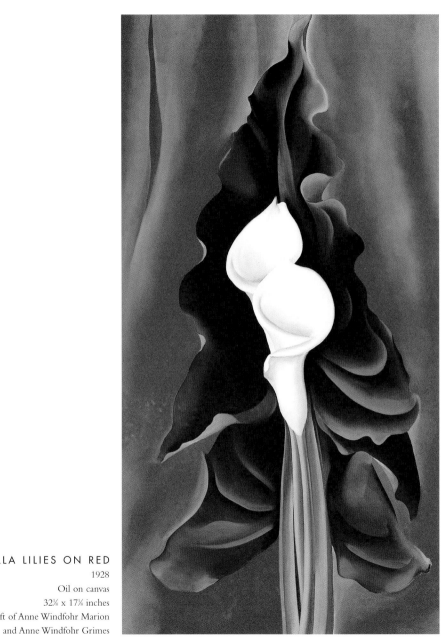

54

CALLA LILIES ON RED
1928
Oil on canvas
32⅛ x 17⅛ inches
Gift of Anne Windfohr Marion
and Anne Windfohr Grimes

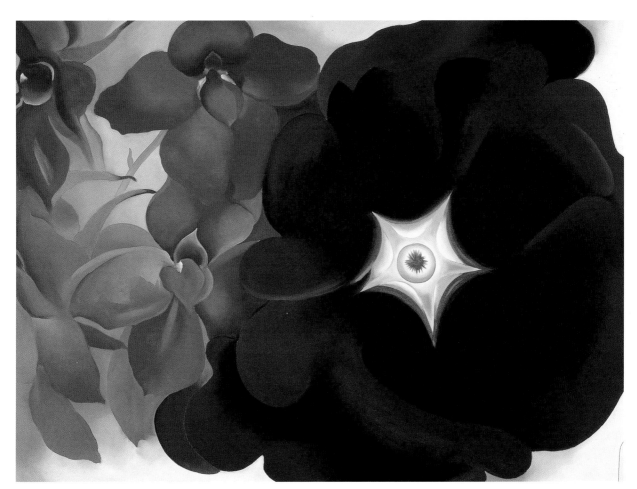

BLACK HOLLYHOCK
BLUE LARKSPUR
1930
Oil on canvas
30⅛ x 40 inches
Extended loan, private collection

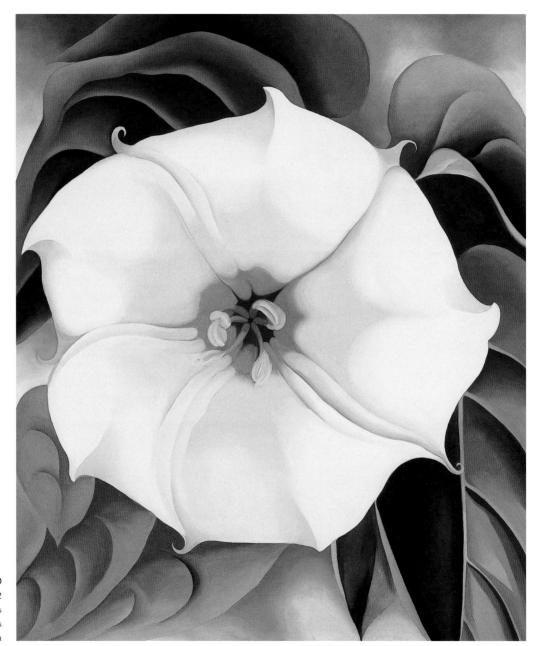

56

JIMSON WEED
1932
Oil on canvas
48 x 40 inches
Gift of The Burnett Foundation

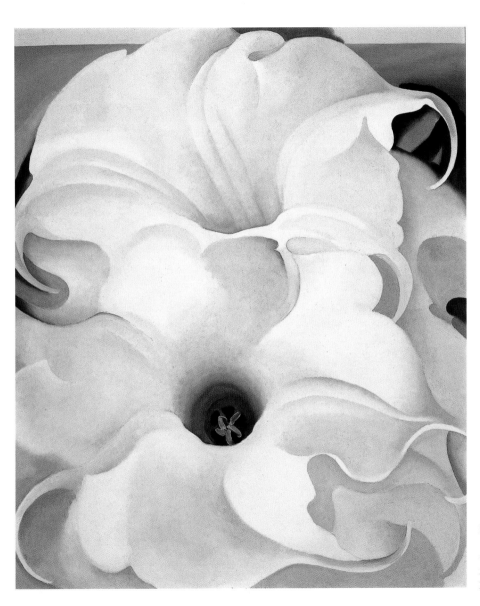

BELLA DONNA
1939
Oil on canvas
36¼ x 30⅛ inches
Extended loan, private collection

LANDSCAPES

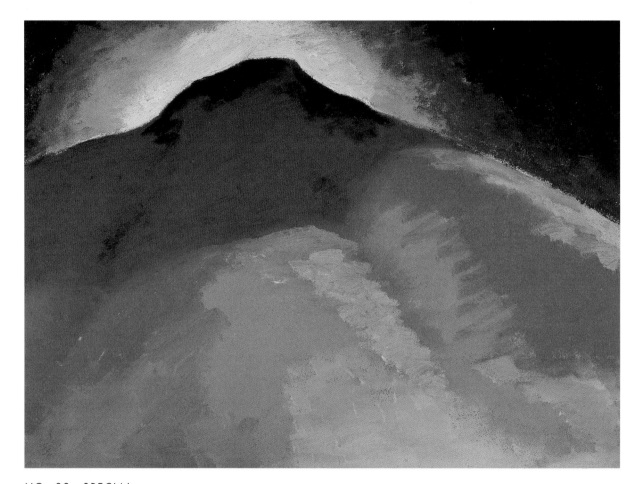

NO. 22—SPECIAL
1916/17
Oil on board
13⅛ x 17¼ inches
Gift of The Burnett Foundation
and The Georgia O'Keeffe Foundation

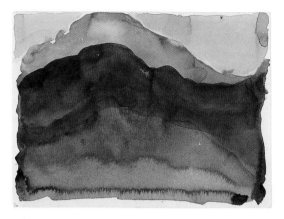

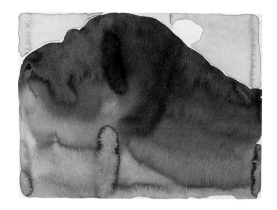

1 PINK AND BLUE MOUNTAIN
1916
Watercolor on paper
8⅞ x 12 inches
Gift of The Burnett Foundation
and The Georgia O'Keeffe Foundation

2 BLUE HILL NO. II
1916
Watercolor on paper
9 x 12 inches
Gift of Dr. and Mrs. John B. Chewning

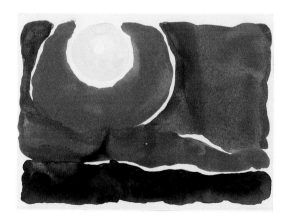

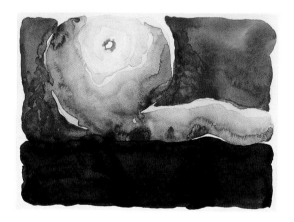

3 EVENING STAR NO. VI
1917
Watercolor on paper
8⅞ x 12 inches
Gift of The Burnett Foundation

4 EVENING STAR NO. VII
1917
Watercolor on paper
8⅞ x 11⅞ inches
Gift of The Burnett Foundation

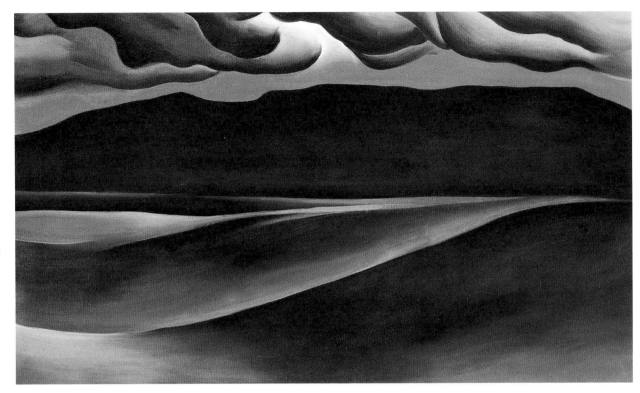

STORM CLOUD, LAKE GEORGE
1923
Oil on canvas
18 x 30⅛ inches
Promised gift, The Burnett Foundation

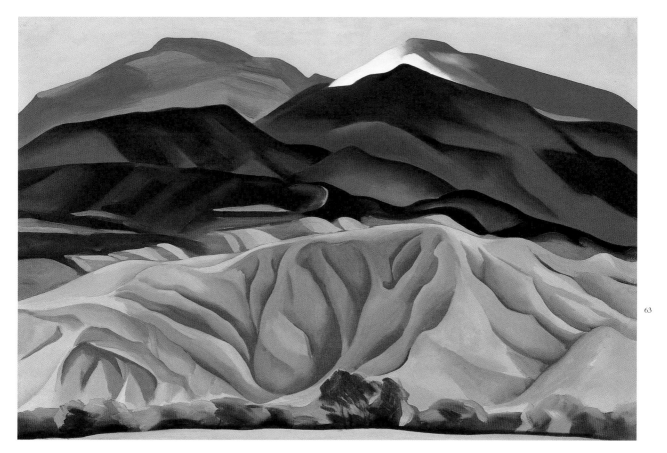

BLACK MESA LANDSCAPE, NEW MEXICO/OUT BACK OF MARIE'S II
1930
Oil on canvas mounted to board
24¼ x 36¼ inches
Gift of The Burnett Foundation

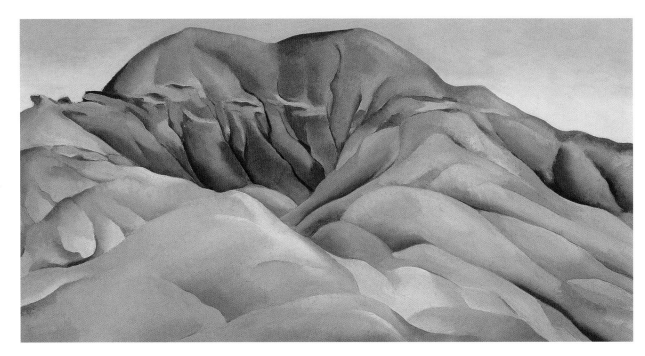

ON THE OLD SANTA FE ROAD
1930/31
Oil on canvas
16 x 30 inches
Promised gift, The Burnett Foundation

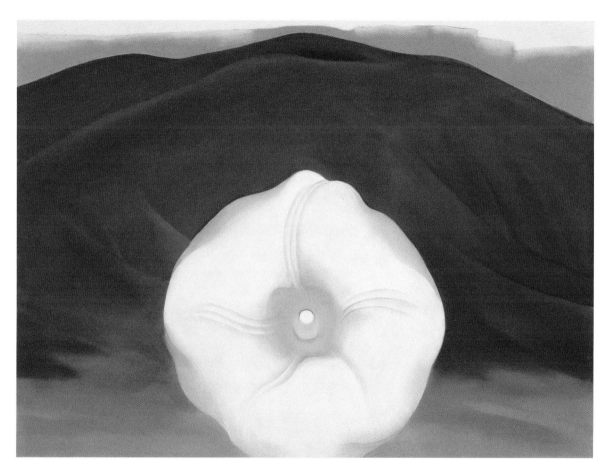

RED HILLS AND WHITE FLOWER
1937
Pastel on paper-covered board
19⅜ x 25⅝ inches
Gift of The Burnett Foundation

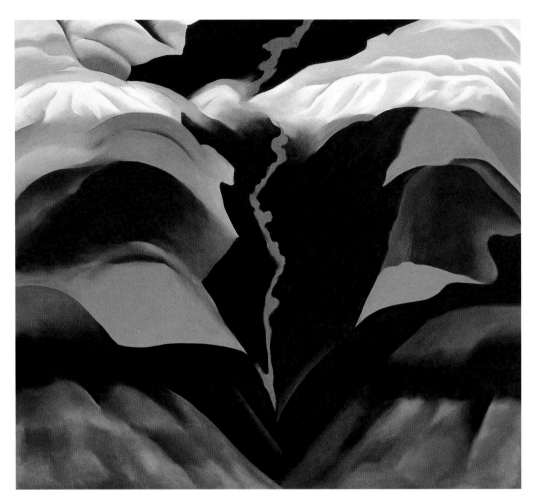

BLACK PLACE III
1944
Oil on canvas
36 x 40 inches
Promised gift, The Burnett Foundation

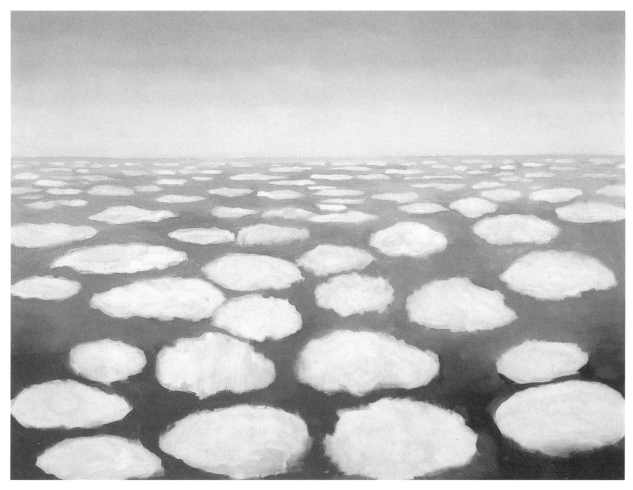

ABOVE THE CLOUDS I
1962/63
Oil on canvas
36⅛ x 48¼ inches
Gift of The Burnett Foundation
and The Georgia O'Keeffe Foundation

TREES

(CONTEXTUALIZED LANDSCAPE FORMS)

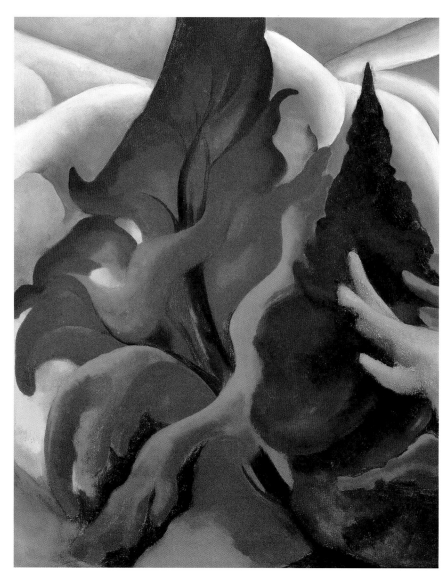

TREES IN AUTUMN
1920/21
Oil on canvas
25¼ x 20¼ inches
Gift of The Burnett Foundation

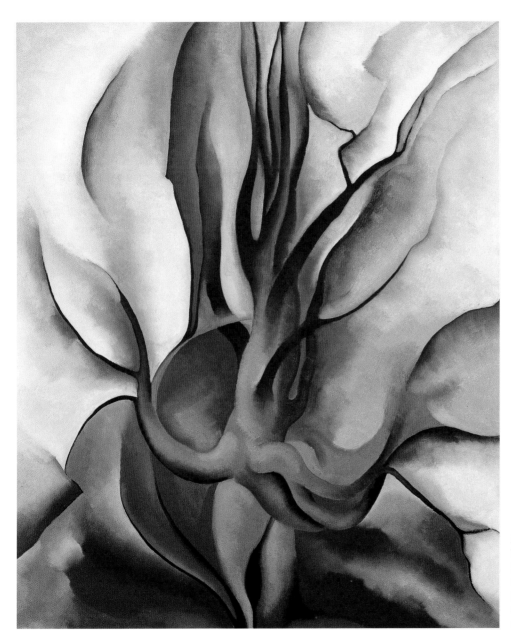

AUTUMN TREES—
THE MAPLE
1924
Oil on canvas
36 x 30 inches
Gift of The Burnett Foundation
and Gerald and Kathleen Peters

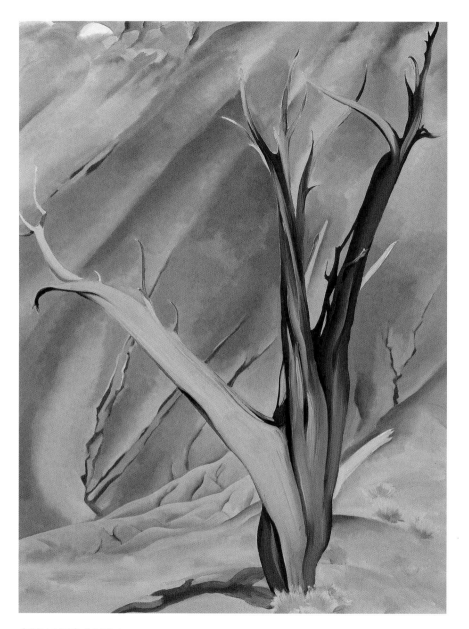

GERALD'S TREE I

1937

Oil on canvas

40 x 30⅛ inches

Gift of The Burnett Foundation

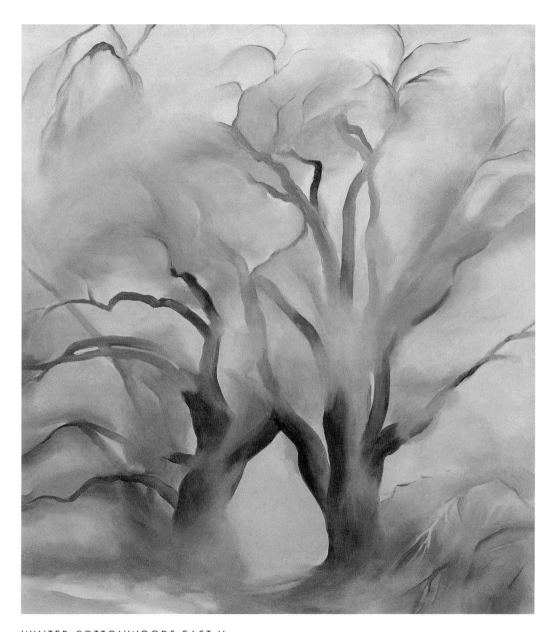

WINTER COTTONWOODS EAST V
1954
Oil on canvas
40 x 36 inches
Gift of The Burnett Foundation

1887 NOVEMBER 15: Georgia Totto O'Keeffe born.

1892–1900 Attends Town Hall School, receives art lessons at home, and furthers art instruction with Sarah Mann, a local watercolorist.

1901–1902 Attends Sacred Heart Academy, Madison, Wisconsin, as a boarder, for her first year of high school.

1902 FALL: O'Keeffe family moves to Williamsburg, Virginia.

1902–1903 Attends Madison High School as a sophomore. JUNE 1903: Joins her family in Williamsburg. FALL: Attends Chatham (Virginia) Episcopal Institute as a boarder.

1905 Graduates in June. Elizabeth May Willis, Chatham's principal and art instructor, recognizes and encourages O'Keeffe's interest in art. In her senior year, O'Keeffe serves as art editor of the school yearbook, *Mortar Board*.

1905–1907 FALL 1905: Attends The School of The Art Institute of Chicago. SUMMER 1906–SUMMER 1907: In Williamsburg, recovering from a lingering illness.

1907–1908 FALL–SPRING: Attends Art Students League, New York; studies with William Merritt Chase, F. Luis Mora, and Kenyon Cox. JUNE 1908: Receives the League's 1907–1908 Still Life Scholarship.

1908–1911 FALL 1908: Works as a freelance commercial artist in Chicago.

ABOUT 1910: Becomes ill with measles; moves to Charlottesville, Virginia, to live with her mother, sisters, and brothers, who moved there from Williamsburg sometime in 1909. FALL 1911: Temporarily takes over Miss Willis's teaching schedule at the Chatham Episcopal Institute.

1912 Attends summer classes at The University of Virginia, Charlottesville, taught by Alon Bement, of Teachers College, Columbia University, New York. He introduces her to the ideas of his mentor, artist-teacher Arthur Wesley Dow, head of the Art Department at Teachers College. AUGUST: Moves to Amarillo, Texas, as supervisor of drawing and penmanship in the public schools; holds this position through spring 1914.

1913 SUMMER: Returns to Charlottesville to work as Bement's assistant at The University of Virginia (continues to teach there summers through 1916).

1914–1915 FALL 1914: Enrolls at Teachers College, Columbia University. FALL 1915: Moves to Columbia, South Carolina, to teach art at Columbia College. OCTOBER 1915: Makes a decision to chart a new direction for her art and produces a seminal series of charcoal abstractions, sending some to her friend Anita Pollitzer in New York during the period October–December.

1916 JANUARY 1: Pollitzer takes a group of O'Keeffe's charcoal drawings to Stieglitz at his gallery, 291. O'Keeffe and Stieglitz soon begin a thirty-year correspondence.

MARCH: Returns to Teachers College to attend the Dow course in methods specified by West Texas State Normal College, Canyon, as a prerequisite to assuming a position there.
MAY 1: O'Keeffe's mother dies in Charlottesville.
MAY 23: Stieglitz opens a group show at 291 that includes 10 of O'Keeffe's charcoal drawings.
JUNE: Leaves New York for Virginia to teach with Bement.
LATE AUGUST: Moves to Texas to begin teaching.

1917 APRIL 3: Stieglitz opens *Georgia O'Keeffe,* the first one-person show of her work, at 291.
AUGUST: Vacations in and around Ward, Colorado. On the way back to Texas, stops in Santa Fe, New Mexico, for the first time.
EARLY WINTER: Becomes ill.

1918 LATE FEBRUARY–MARCH: Is granted a leave of absence from teaching responsibilities and, on February 21, moves first to San Antonio, then, in March, to a farm in Waring, Texas.
JUNE 10: Moves to New York at Stieglitz's invitation.
JULY 8: Stieglitz leaves Emmeline Obermeyer Stieglitz, his wife since 1893, to live with O'Keeffe; she resigns from West Texas State, accepting Stieglitz's offer to underwrite a year of painting.
NOVEMBER 11: O'Keeffe's father dies.

1921 FEBRUARY 7: Stieglitz retrospective exhibition opens at The Anderson Galleries (145 prints, 1886–1921); several nudes among the 45 photographs of O'Keeffe create a sensation with public and critics.

1923 JANUARY 29: Stieglitz opens *Alfred Stieglitz Presents One Hundred Pictures: Oils, Water-colors, Pastels, Drawings, by Georgia O'Keeffe, American* at

The Anderson Galleries. He organizes exhibitions of her work annually until his death in 1946.

1924 MARCH 3: *Alfred Stieglitz Presents Fifty-One Recent Pictures: Oils, Water-colors, Pastels, Drawings, by Georgia O'Keeffe, American* opens at The Anderson Galleries.
SEPTEMBER 9: Stieglitz's divorce becomes final.
DECEMBER 11: O'Keeffe and Stieglitz marry.

1925 MARCH 9: *Alfred Stieglitz Presents Seven Americans: 159 Paintings, Photographs & Things, Recent & Never Before Publicly Shown, by Arthur G. Dove, Marsden Hartley, John Marin, Charles Demuth, Paul Strand, Georgia O'Keeffe, Alfred Stieglitz* opens at The Anderson Galleries.
MID-NOVEMBER: O'Keeffe and Stieglitz move to the Shelton Hotel.

1926 FEBRUARY 11: *Fifty Recent Paintings, by Georgia O'Keeffe* opens at The Intimate Gallery.

1927 JANUARY 11: *Georgia O'Keeffe: Paintings, 1926* opens at The Intimate Gallery.
JUNE 6: The first retrospective, *Paintings by Georgia O'Keeffe,* opens at The Brooklyn Museum.

1928 JANUARY 9: *O'Keeffe Exhibition* opens at The Intimate Gallery.

1929 FEBRUARY 4: *Georgia O'Keeffe: Paintings, 1928* opens at The Intimate Gallery.
APRIL 27: O'Keeffe travels to Santa Fe; shortly after arrival, moves to Taos as guest of Mabel Dodge Luhan, who provides her with a studio.
DECEMBER 13: *Paintings by 19 Living Americans,* with five works by O'Keeffe, opens at the Museum of Modern Art, New York.

1930 FEBRUARY 4: *Georgia O'Keeffe: 27 New Paintings, New Mexico, New York, Lake George, Etc.* opens at An American Place.
LATE APRIL: O'Keeffe travels to New Mexico.

1931 DECEMBER 27: *Georgia O'Keeffe: 33 New Paintings (New Mexico)* opens at An American Place.

1932 APRIL: Accepts a $1,500 commission to paint a mural for the ladies room in Radio City Music Hall, scheduled to open at end of year.
JUNE AND AUGUST: Travels to Canada to paint.
OCTOBER: Abandons Radio City Music Hall commission and stops painting entirely.

1933 JANUARY 7: *Georgia O'Keeffe: Paintings—New & Some Old* opens at An American Place.
FEBRUARY: O'Keeffe admitted to Doctor's Hospital, New York, suffering from psychoneurosis.
MARCH–APRIL: Recuperates in Bermuda. Recovers sufficiently to begin drawing at Lake George in October.

1934 JANUARY: Begins painting after a fifteen-month hiatus.
JANUARY 29: *Georgia O'Keeffe at 'An American Place,' 44 Selected Paintings 1915–1927* opens at An American Place.
MARCH–APRIL: Travels to Bermuda.
JUNE: Travels to New Mexico.
AUGUST: First visit to Ghost Ranch, a dude ranch north of Abiquiu.

1935 JANUARY 27: *Georgia O'Keeffe: Exhibition of Paintings (1919–1934)* opens at An American Place.
JULY: Travels to New Mexico.

1936 JANUARY 7: *Georgia O'Keeffe: Exhibition of Recent Paintings, 1935* opens at An American Place.
APRIL: O'Keeffe and Stieglitz move from the Shelton Hotel to a penthouse apartment at 405 East 54th Street.
JUNE: O'Keeffe travels to New Mexico; spends her first summer at the house at Ghost Ranch that she will buy in 1940—Rancho de los Burros.

1937 FEBRUARY 5: *Georgia O'Keeffe: New Paintings* opens at An American Place.
JULY: Goes to New Mexico.
DECEMBER 27: *Georgia O'Keeffe: The 14th Annual Exhibition of Paintings with Some Recent O'Keeffe Letters* opens at An American Place.

1938 MAY: O'Keeffe receives an honorary degree from the College of William and Mary, the first of many she will receive during her lifetime.

1939 JANUARY 22: *Georgia O'Keeffe: Exhibition of Oils and Pastels* opens at An American Place.
JANUARY–APRIL: O'Keeffe travels to Hawaii to produce paintings for a Dole Company promotional campaign.

1940 FEBRUARY 3: *Georgia O'Keeffe: Exhibition of Oils and Pastels* opens at An American Place.
AUGUST: Goes to New Mexico.

1941 JANUARY 27: *Exhibition of Georgia O'Keeffe* opens at An American Place.
MAY: Goes to New Mexico.

1942 FEBRUARY 2: *Georgia O'Keeffe: Exhibition of Recent Paintings, 1941* opens at An American Place.
JUNE: Goes to New Mexico.
OCTOBER: O'Keeffe and Stieglitz move to 59 East 54th Street, her last New York address.

1943 JANUARY: Goes to Chicago to install and attend events related to the January 21 opening of a retrospective, *Georgia O'Keeffe*, at the Art Institute of Chicago.

MARCH 27: *Georgia O'Keeffe: Paintings—1942–1943* opens at An American Place.
APRIL: Goes to New Mexico.

1944 JANUARY: *Georgia O'Keeffe: Paintings—1943* opens at An American Place.
APRIL: Goes to New Mexico.

1945 JANUARY 22: *Georgia O'Keeffe: Paintings, 1944* opens at An American Place.
MAY: Goes to New Mexico.
DECEMBER: Purchases Abiquiu property from the Catholic Archdiocese of Santa Fe.

1946 FEBRUARY 4: *Georgia O'Keeffe* opens at An American Place. O'Keeffe begins organizing a retrospective, *Georgia O'Keeffe*, which opens at The Museum of Modern Art on May 14.
JULY 13: Stieglitz dies.
LATE SEPTEMBER: Goes to New Mexico.

1947 JANUARY–EARLY SUMMER: Stays in New York—where she primarily lives until 1949—settling Stieglitz's estate.

1949 JUNE: Moves permanently to New Mexico and habitually spends winter and spring in Abiquiu, summer and fall at Ghost Ranch.

1950 JULY: Begins organizing *Georgia O'Keeffe: Paintings 1946–1950*, which opens at An American Place in October. Edith Halpert, owner of The Downtown Gallery, becomes O'Keeffe's exclusive agent.

1951 FEBRUARY–MARCH: Travels to Mexico.

1959 JANUARY–APRIL: Travels to Southeast Asia, the Far East, India, the Middle East, and Italy.

1960 JULY: Helps organize *Georgia O'Keeffe: Forty Years of Her Art*, a retrospective that opens on October 4 at the Worcester (Massachusetts) Art Museum.
LATE OCTOBER–NOVEMBER: Makes second trip to Asia.

1961 SPRING: Helps organize and install what will be her last exhibition at The Downtown Gallery, *Georgia O'Keeffe: Recent Paintings and Drawings*, which opens on April 11. Doris Bry becomes O'Keeffe's exclusive agent.

1966 MARCH: Attends the opening of a retrospective, *Georgia O'Keeffe: An Exhibition of the Work of the Artist from 1915 to 1966*, that opens at the Amon Carter Museum of Western Art, Fort Worth, March 17.

1970 EARLY OCTOBER: Installs retrospective, *Georgia O'Keeffe*, that opens at the Whitney Museum of American Art on October 8.

1971 EARLY IN THE YEAR: Loses her central vision, retaining only peripheral sight.

1972 During the year, completes her last unassisted oil painting, but continues to work in oil with assistance until 1977. (Works unassisted in watercolor and charcoal until 1978 and in graphite until 1984.)

1973 NOVEMBER: Meets potter-sculptor Juan Hamilton, who becomes her assistant and, later, her close friend and representative. Begins working in clay; with assistance in 1980.

1977 JANUARY: Receives the Medal of Freedom from President Gerald Ford.

1984 MARCH: Moves to Santa Fe.

1985 Receives the National Medal of Arts from President Ronald Reagan.

1986 MARCH 6: O'Keeffe dies at St. Vincent's Hospital, Santa Fe.

BARBARA BUHLER LYNES

I want to thank each of the many individuals at the Georgia O'Keeffe Museum who have contributed to the realization of this book and to extend special thanks to George G. King, Director, who strongly supported this publication and graciously provided its foreword; Jenifer Jovais, Exhibitions Coordinator, and Kathryn Olcott, Director of Retail Services, whose thoughtfulness and attention to detail have greatly facilitated all aspects of this project. And at Harry N. Abrams, Inc., many thanks to Margaret L. Kaplan, Editor-at-Large; Jennifer Joy, Editorial Assistant; Allison Henry, Designer; and Jane Searle, Production Manager, for their kind help and support.

BARBARA BUHLER LYNES

Curator, Georgia O'Keeffe Museum

The Emily Fisher Landau Director, Georgia O'Keeffe Museum Research Center

PROJECT DIRECTOR: Margaret L. Kaplan
DESIGNER: Allison Henry
PRODUCTION MANAGER: Jane Searle

Library of Congress Cataloging-in-Publication Data

Lynes, Barbara Buhler
Georgia O'Keeffe Museum: Highlights From The Collection / by
Barbara Buhler Lynes.
p. cm.
Includes bibliographical references and index.
ISBN 0-8109-9153-5 (pbk.)
1. O'Keeffe, Georgia, 1887-1986—Catalogs.
2. Painting—New Mexico—Santa Fe—Catalogs. 3. Georgia O'Keeffe Museum—Catalogs.
I. O'Keeffe, Georgia, 1887-1986. II. Georgia O'Keeffe Museum. III. Title.

ND237.O5 A4 2003
759.13—dc21
2002153493

Published in 2003 by Harry N. Abrams, Incorporated, New York.

Printed and bound in Japan

10 9 8 7 6 5 4 3 2 1

Harry N. Abrams, Inc.
100 Fifth Avenue
New York, N.Y. 10011
www.abramsbooks.com

Abrams is a subsidiary of
LA MARTINIÈRE
GROUPE